RED SHOES

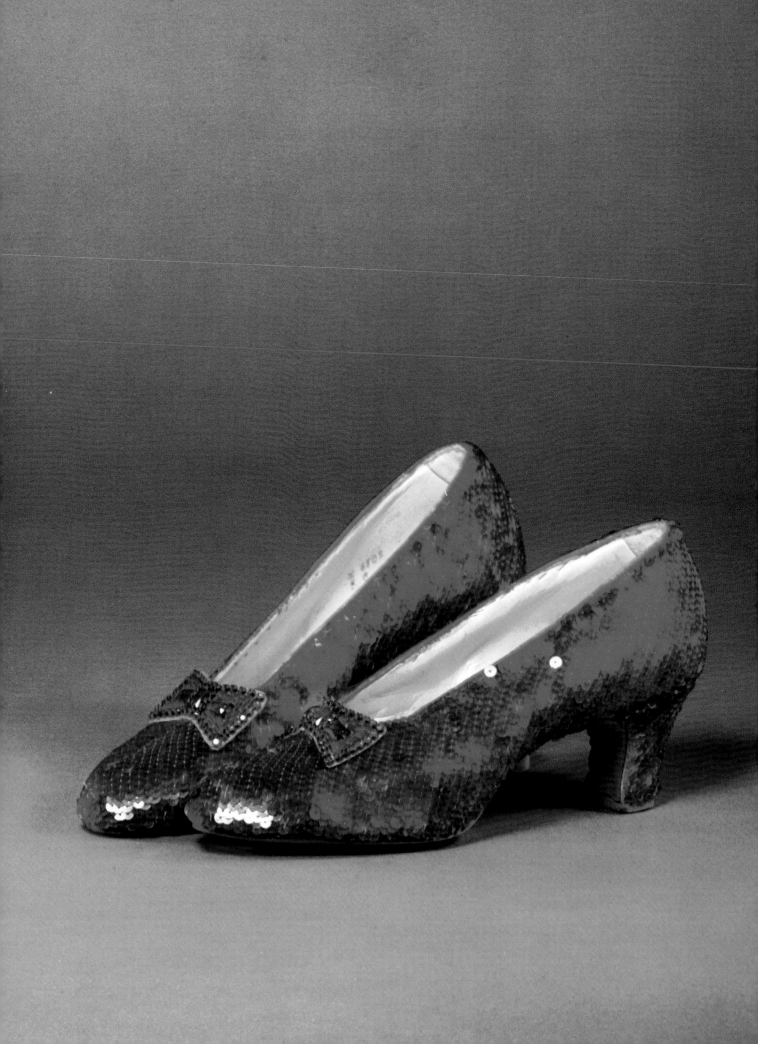

RED SHOES

Kenn Duncan

UNIVERSE BOOKS
New York

Frontispiece: The original "ruby slippers" from the film, *The Wizard of Oz*.

RED SHOES is a production of Kenn Duncan and Thunder Key, Inc.

Published in the United States of America in 1984
by Universe Books
381 Park Avenue South, New York, N.Y. 10016

Library of Congress Catalog Number 84-40350
ISBN 0-87663-444-7

84 85 86 87 88 / 10 9 8 7 6 5 4 3 2 1

Design by Kay Douglas

Printed in Hong Kong

To a love of life

When the voice on the phone said, "Would you be part of my red shoes exhibition?" I thought it was some unbalanced Judy Garland fan and hung up, having had an assortment of crank calls that day, including a woman claiming to be the reincarnated Eva Tanguay. When a friend of Kenn Duncan's told me he was surprised at my rudeness, I realized my error.

Judy Garland *did* figure in the evolution of this exhibition, and although the shoes I wear in my photograph are clearly not hers, nor was I privileged to see or touch the originals, it was fun being photographed by Kenn. He has a way of making a picture session enjoyable—a rare trait indeed among photographers. Usually they are numbingly boring experiences during which one is *ordered* to smile. (I always say, grimly, "This is my smile" or "Can you give me a little more zazz?" or something equally nauseating.)

Kenn seems to convey his own enjoyment to his "models" so that you don't feel like you've been to the dentist but to a small and pleasant party.

Besides his talent for making his subjects comfortable, he clearly has the artist's eye, the craftsman's skill, and the imagination to conceive and bring novel ideas to life. Only a magician of the lens could transform the fiery Chita Rivera into a frothy Jean Harlow, or me into a young Burt Lancaster in his circus acrobat days. (Actually, my perhaps puzzling presence on the bar was inspired by Kenn's knowledge of my former prowess as a champion gymnast in my Nebraska youth.) In each case, he created a setting and atmosphere that set his models off in a unique and charming manner. Who else would have Liv Ullman step out of an Erté painting so fetchingly? Kenn could probably, if he chose, make Howard Cosell winsome.

His portfolio of ingeniously conceived red-shoe photos continues to grow. I wish it continued success and that I had sucked in my gut more.

—Dick Cavett

"Only a magician of the lens . . .
could transform me into
a young Burt Lancaster."

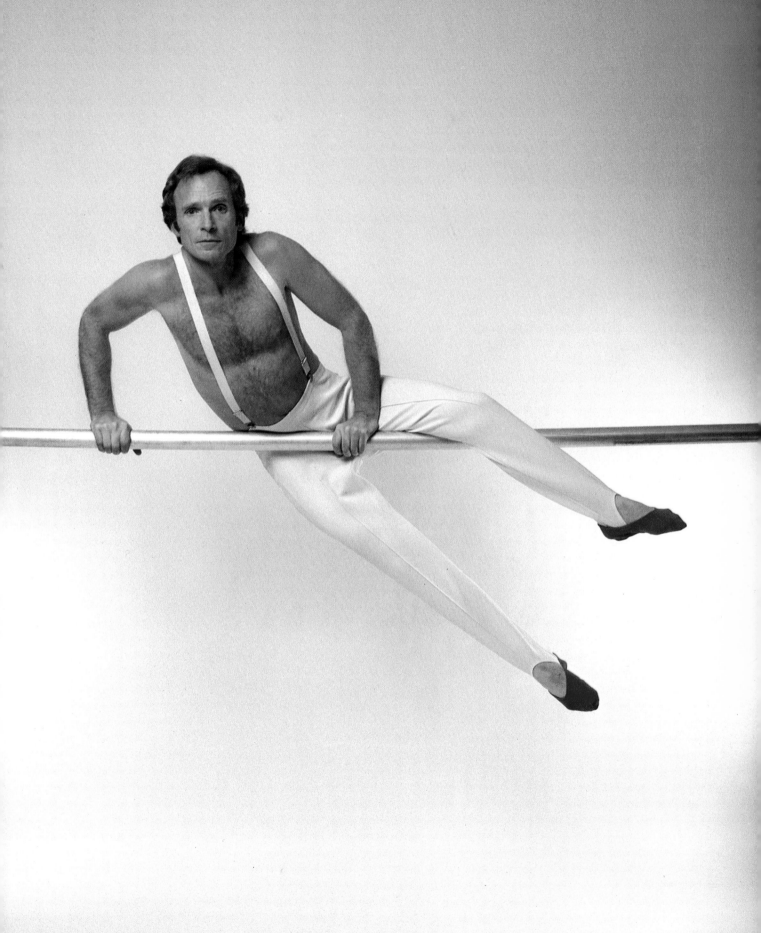

Another charming
``fair lady'' from England.

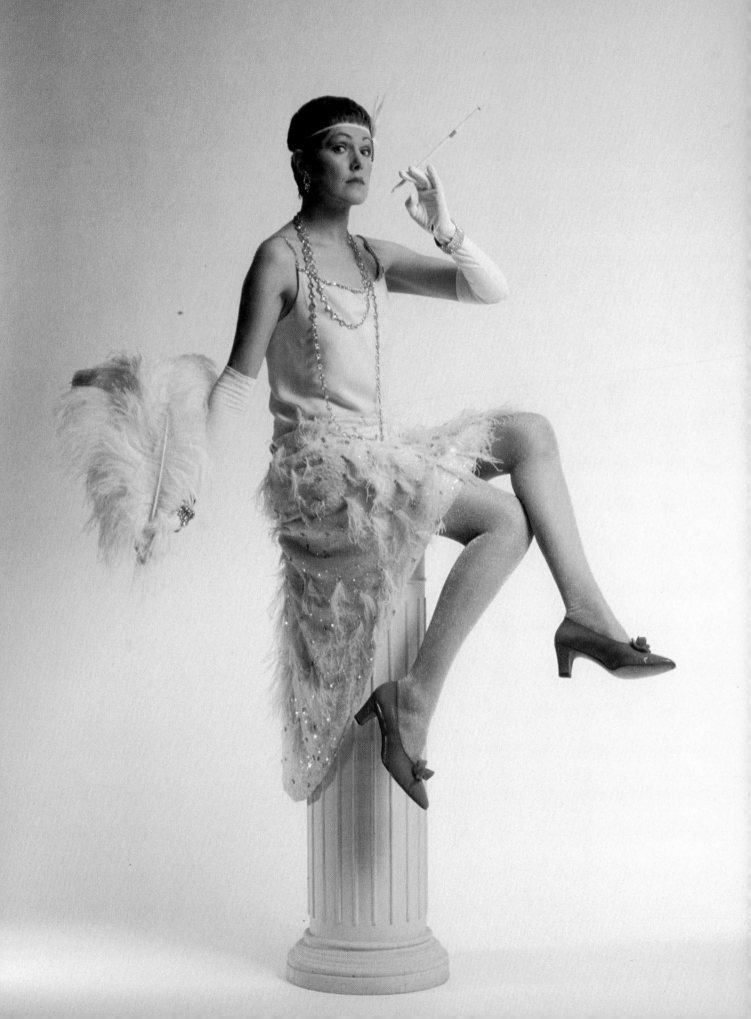

To know him is to love him.

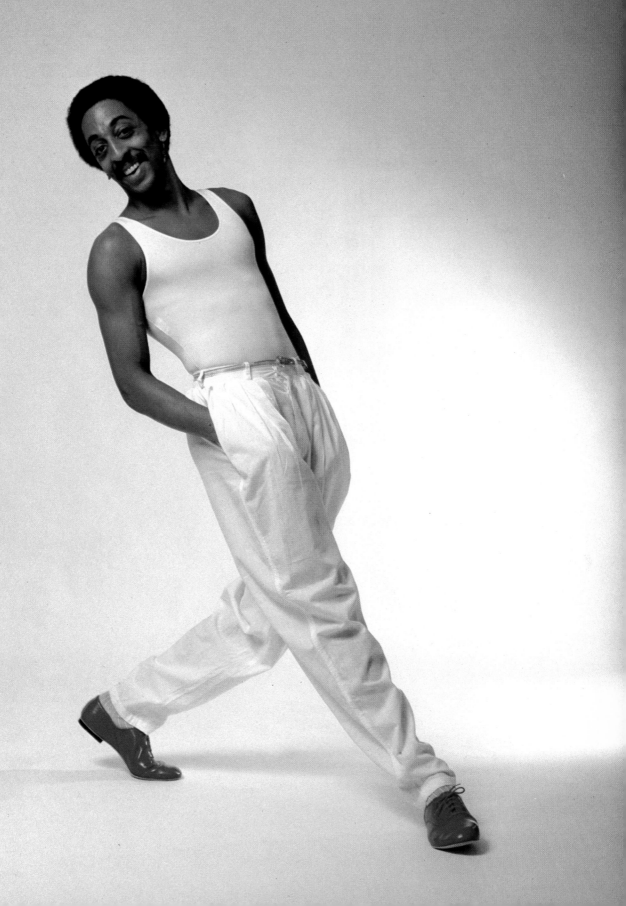

An exquisite Erté painting
come to life—dog and all.

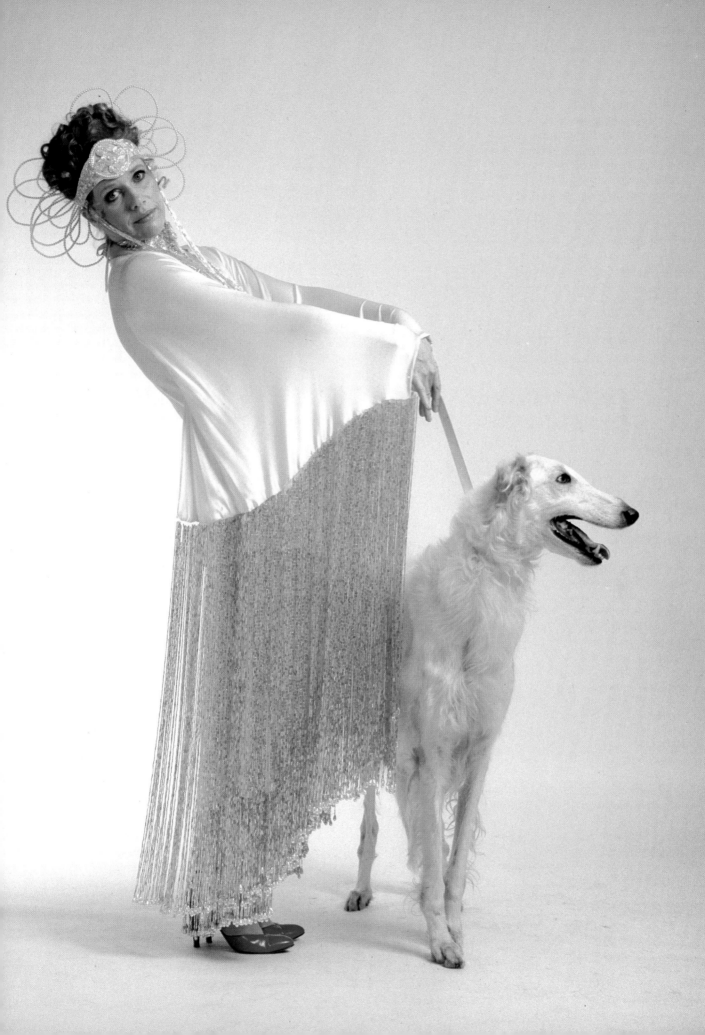

Dimpled knees and his
famous white cap —
all he needed to complete the
picture were his red shoes.

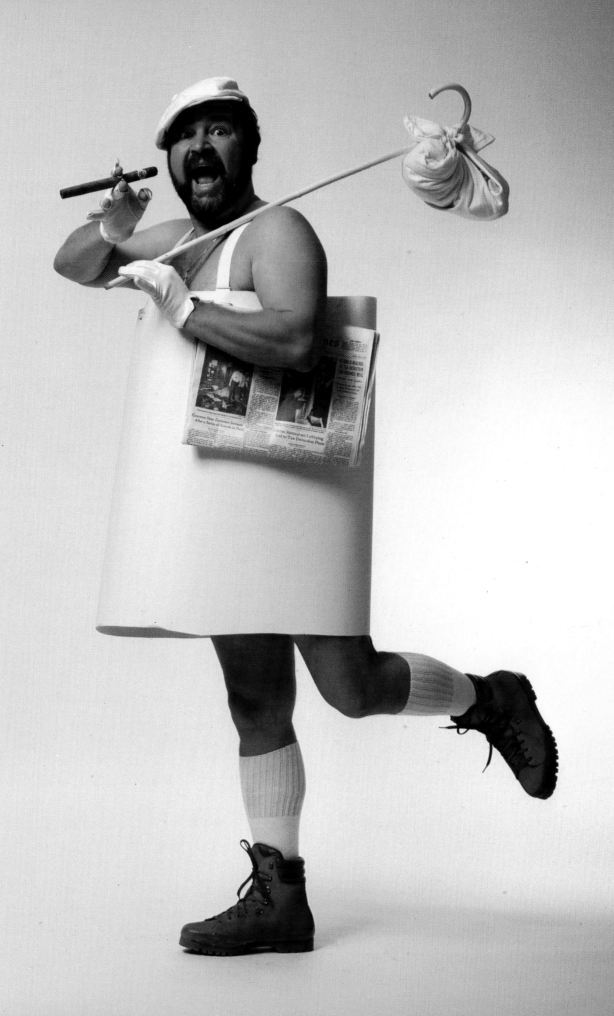

She's the cat's meow.

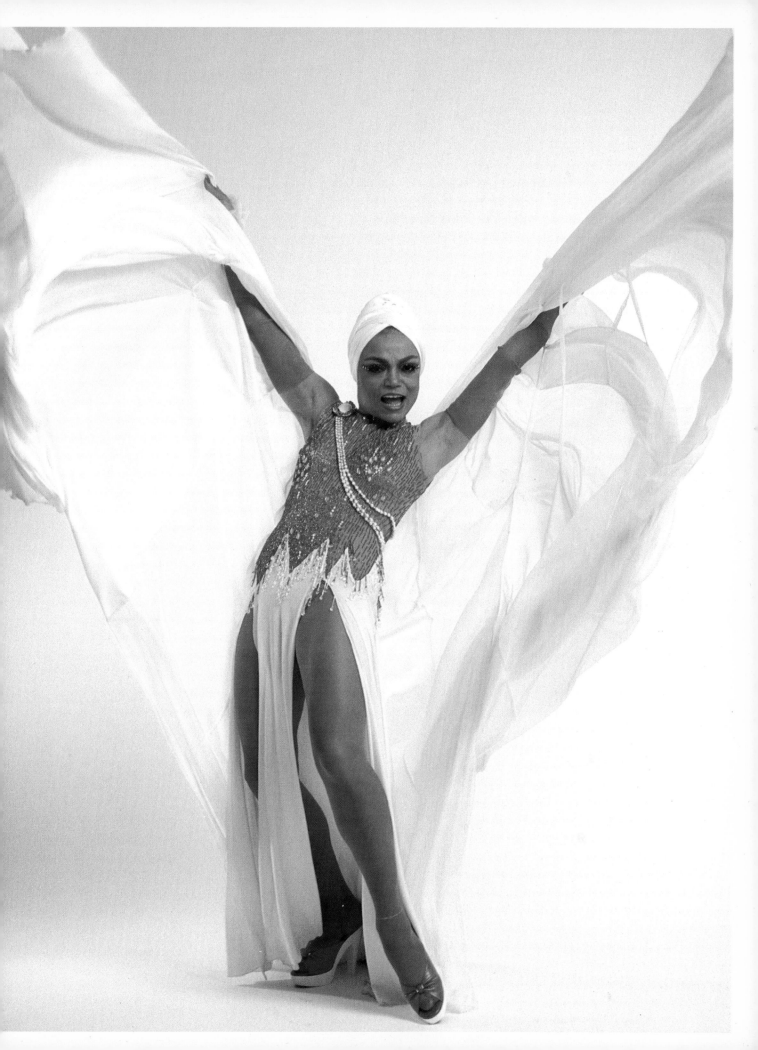

The man of many faces.
To be or not to be . . .
it is in the mind of the beholder.

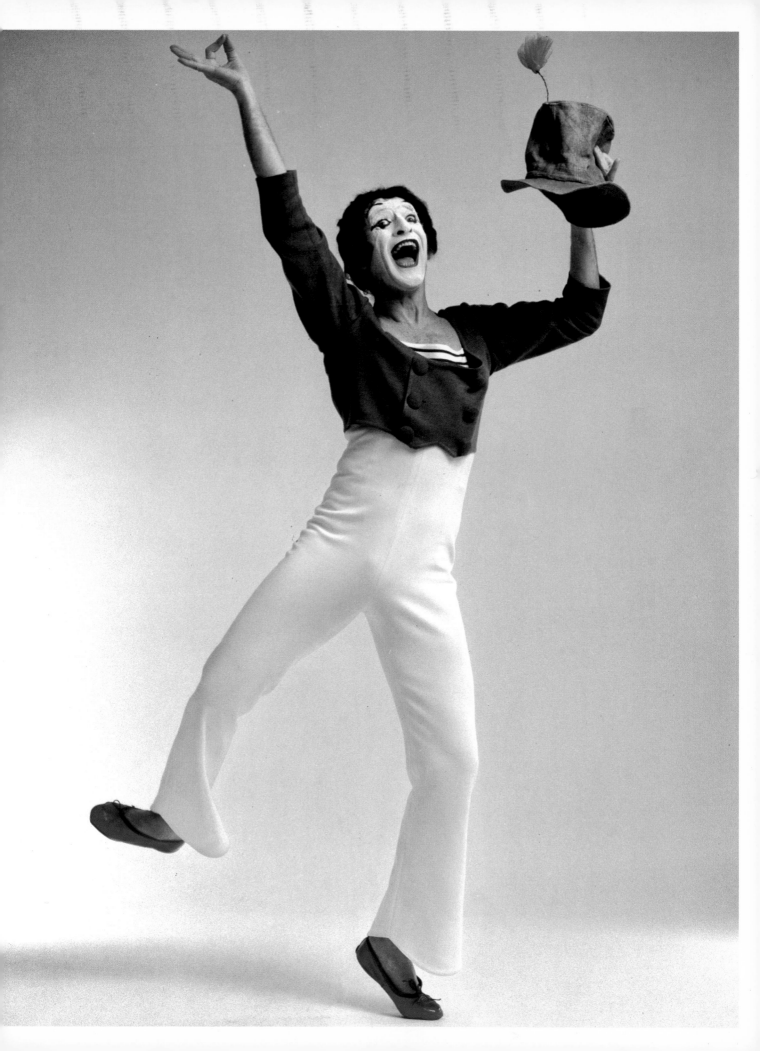

One of the greatest
dancers of our time and,
like a chameleon, ever changing:
artistic director, choreographer,
dancer, actor—a consummate
artist.

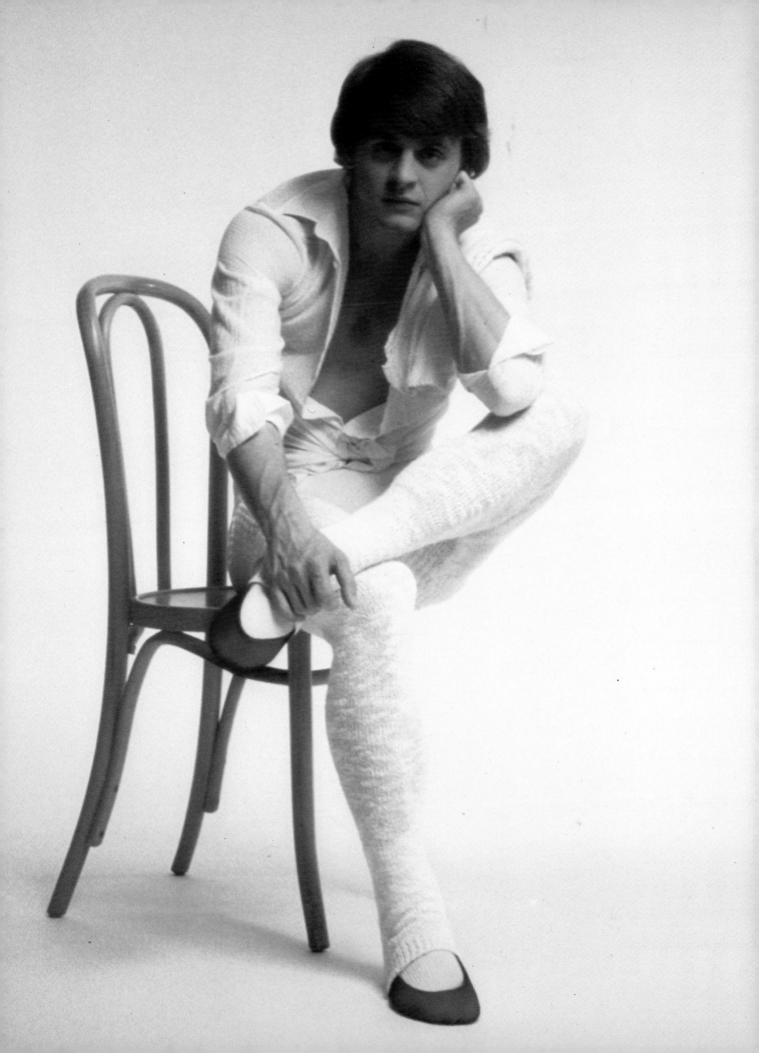

Innocent, elegant, kind, and
honest—and a voluptuous body
we rarely get to see.

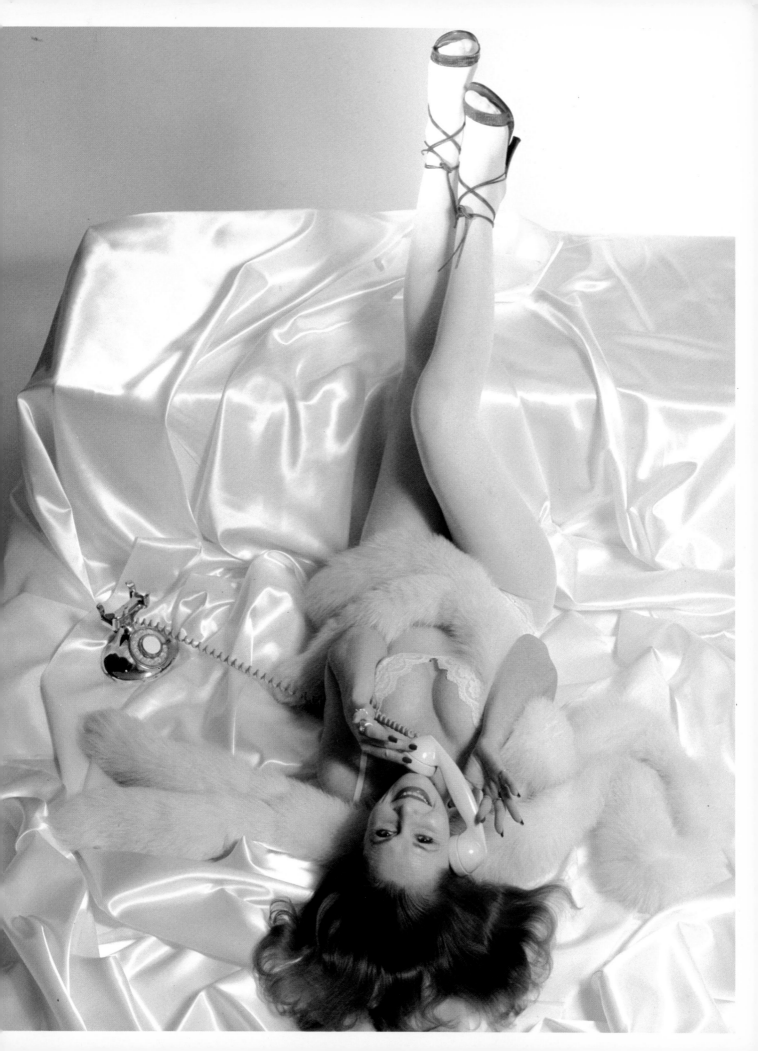

His two greatest
musical ladies are, of course,
Dolly Levi and Auntie Mame.
But there was another lady for
whom he always wanted to play.

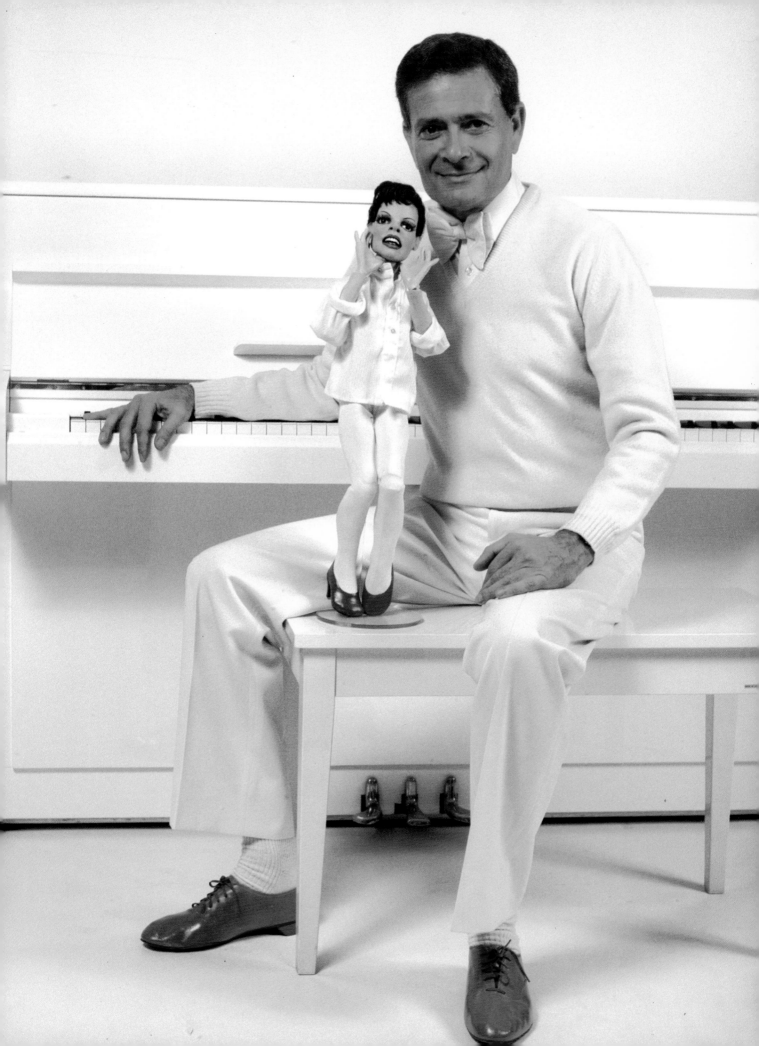

It's so nice to have
you back where you belong.

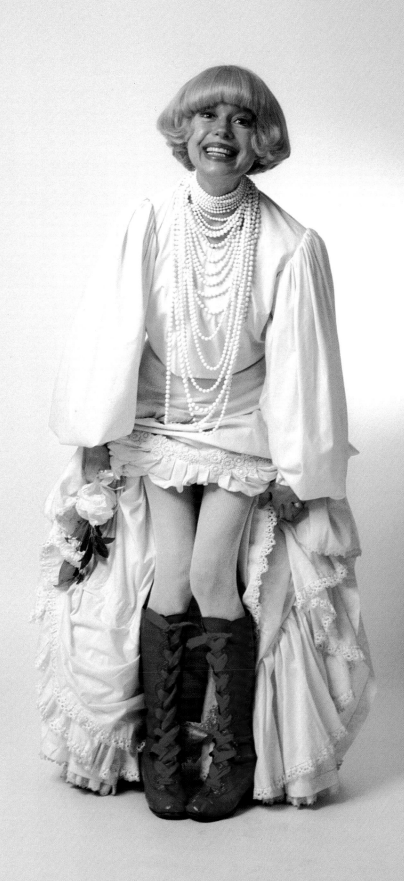

He had just completed the filming
of *A Streetcar Named Desire*
with Ann-Margret....What a treat.
He could be the prince
of any city.

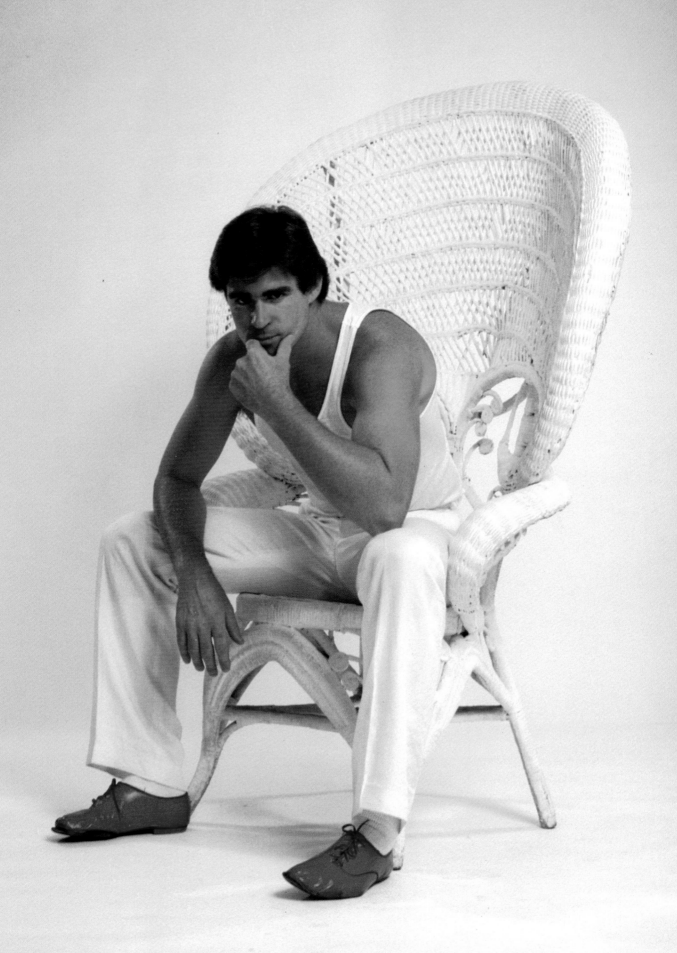

"I love cooking and I'm tired
of being buttoned up to my chin....
It's great what one can do
with a little shaving cream."

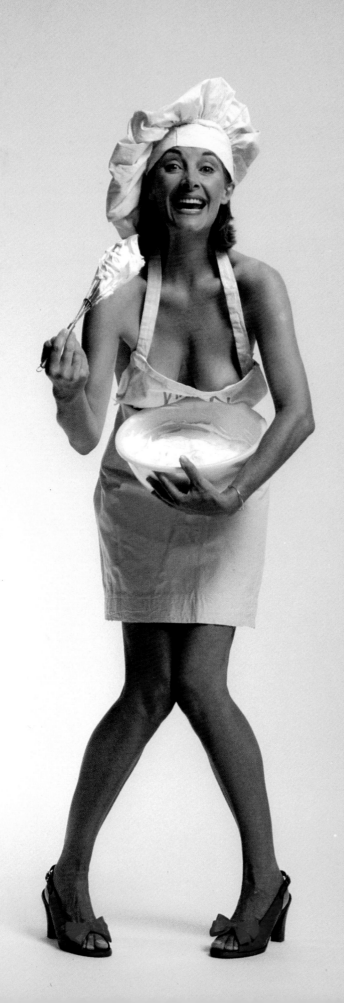

When he does things he
does them in a big way!

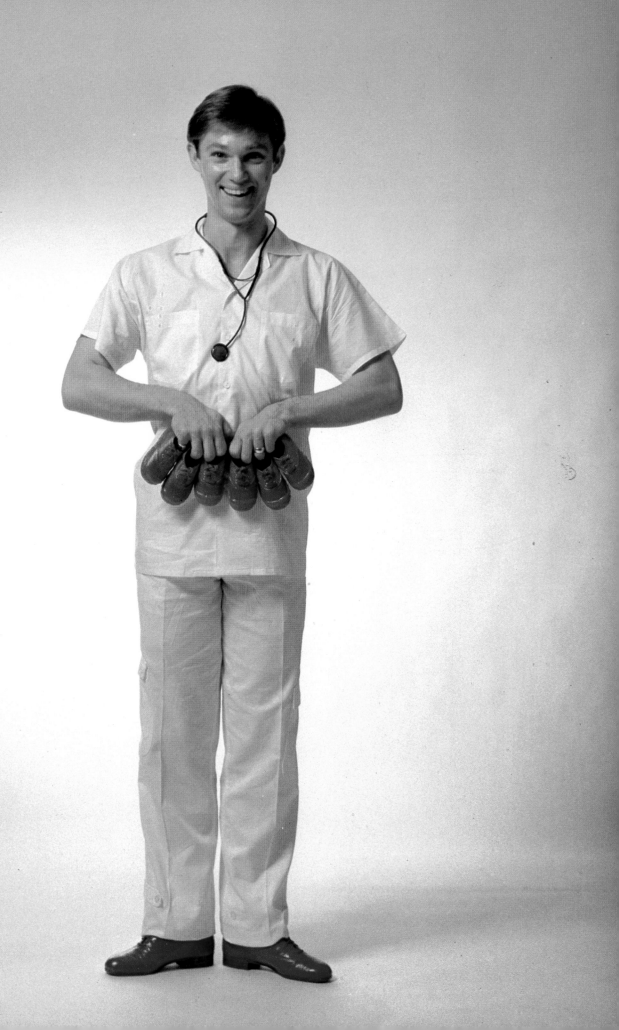

She can slide down a
gilded staircase or stuff a
meat pie, troop down the sewers
of Paris, or take a role made
famous by Ethel Merman and
make it her own.
As her husband, Patrick, said,
"She's my best girl."

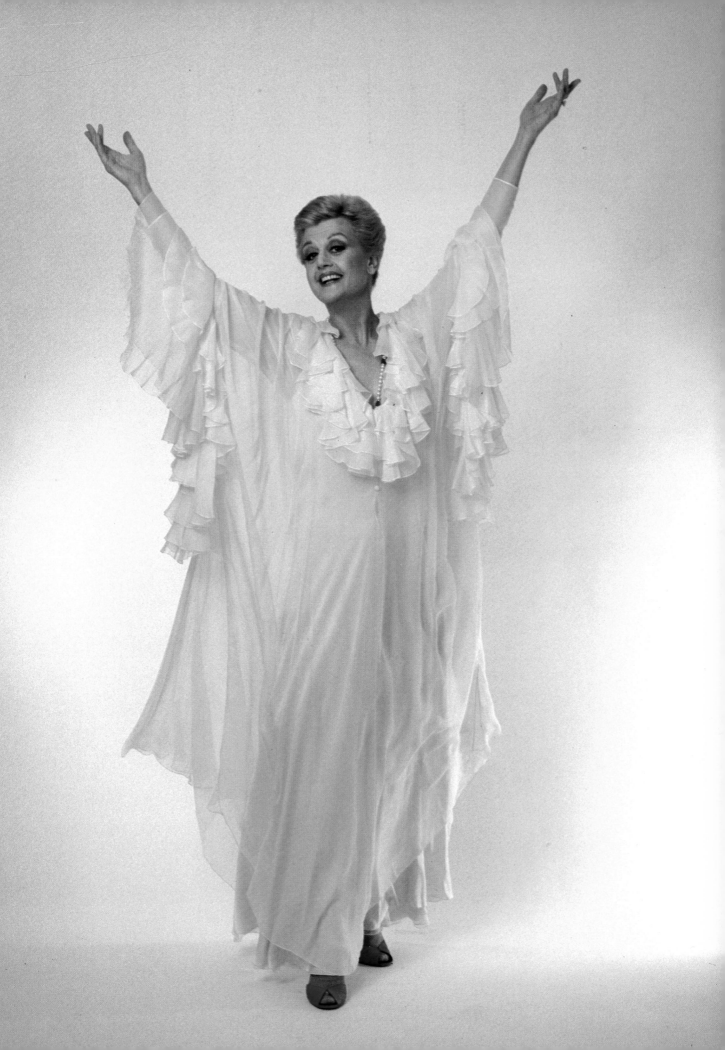

Charismatic and magnificent,
and celebrating the joy
of life.....Cheers!

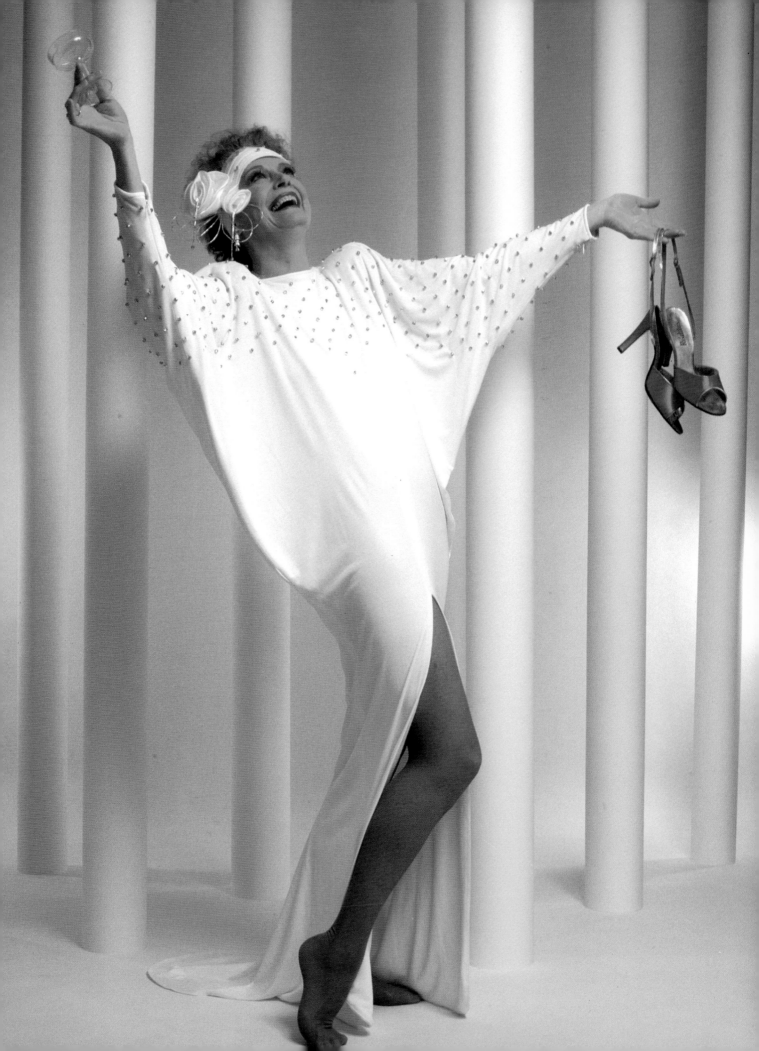

Touché! (Term used to acknowledge a "hit" in fencing.)

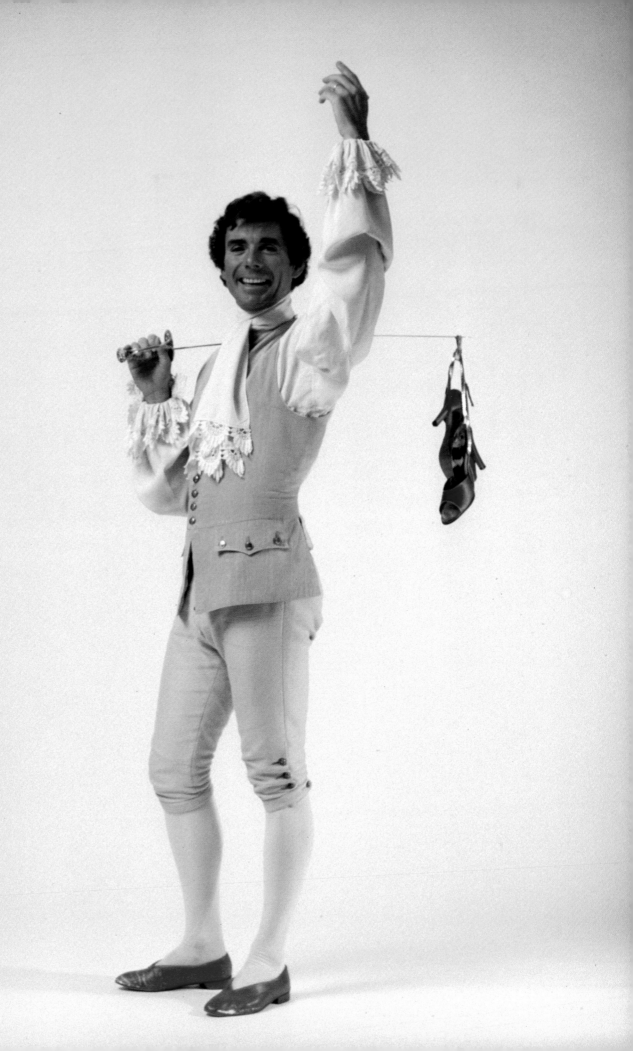

This Latin beauty,
for a change, fantasized about
being . . . Jean Harlow.

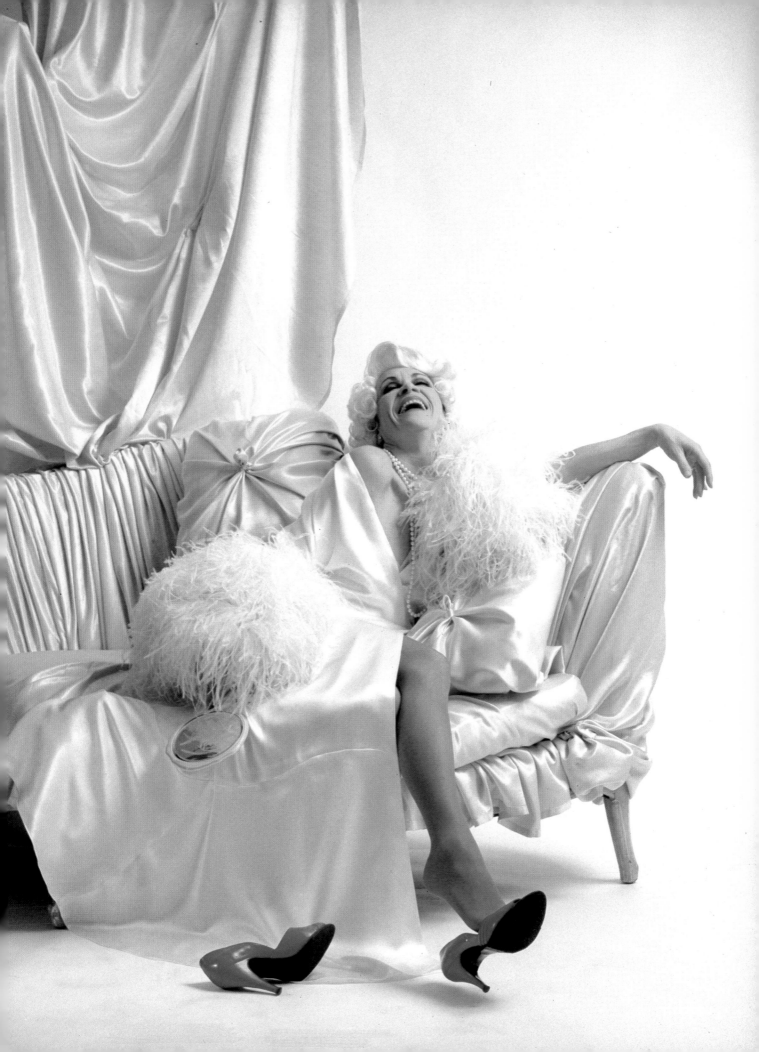

Generous spirited...
I photographed him while he
was starring as Father Tim Farley
in *Mass Appeal.*
How much closer
to heaven can one be?

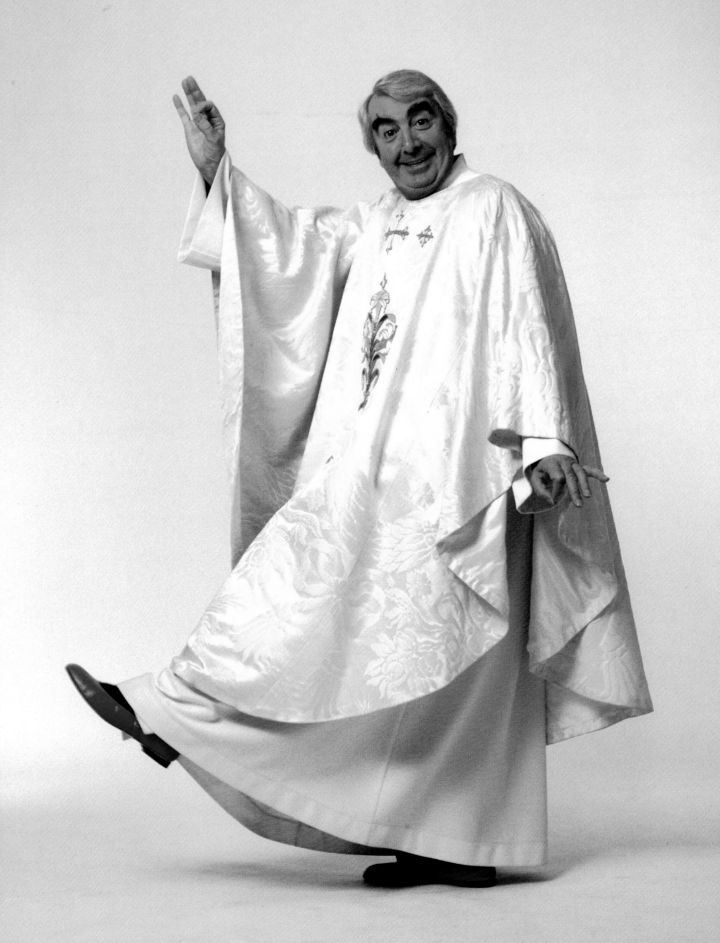

Like her balloon,
she floats in the breeze
with her high notes.

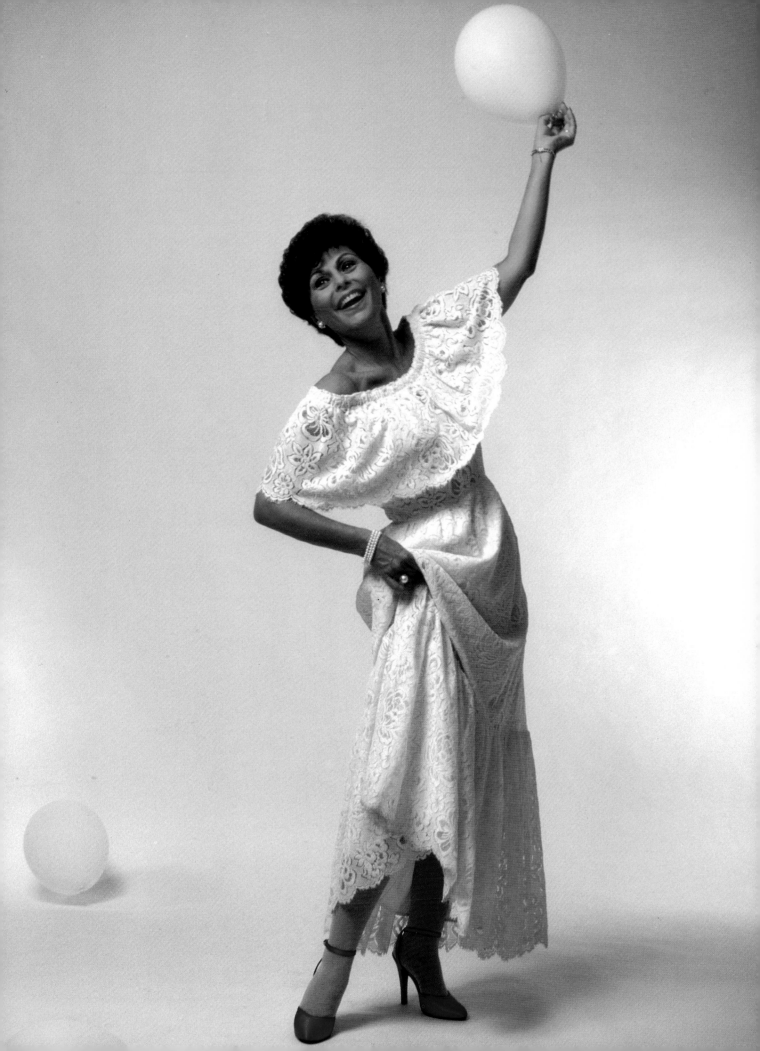

A seductress for any
season...with smoldering eyes
no one can forget.

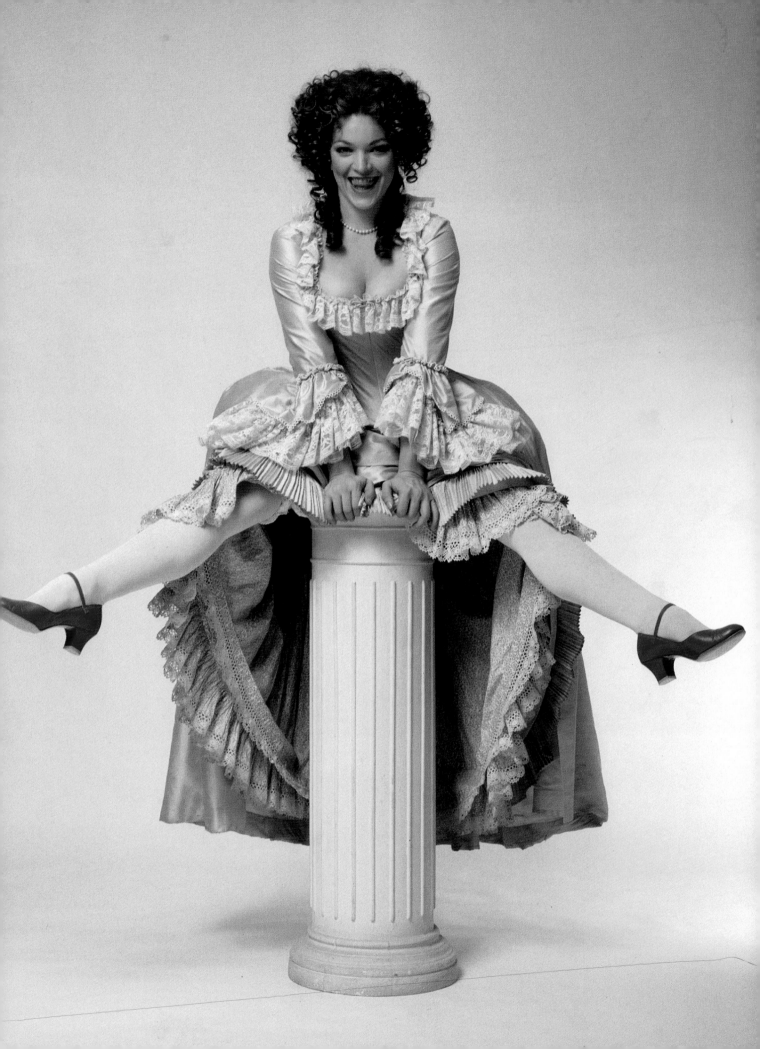

I photographed him while
he was in New York performing
as Nicholas Nickleby.
For this photo session he wanted
to be very American—and what's
more American than a cowboy?

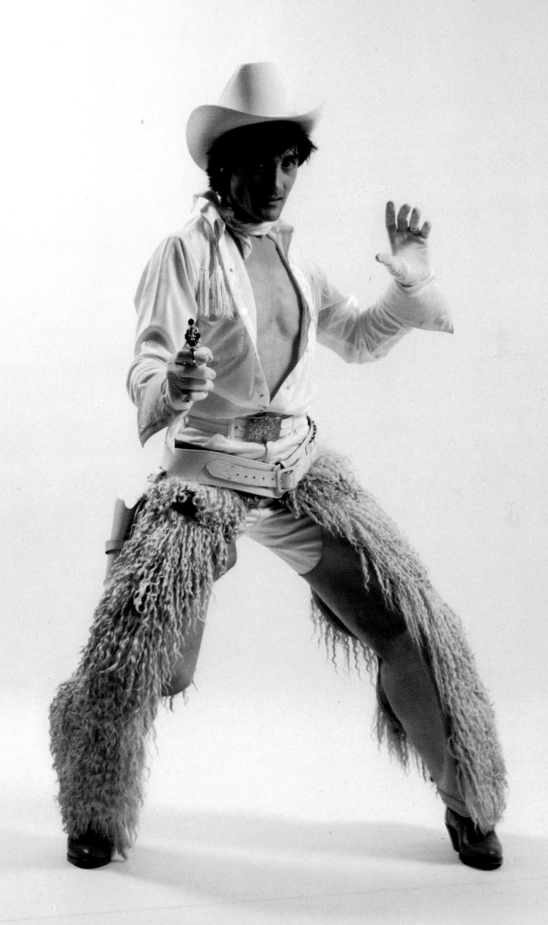

After photographing them,
I felt as if I had known
these two wonderful people
all my life.

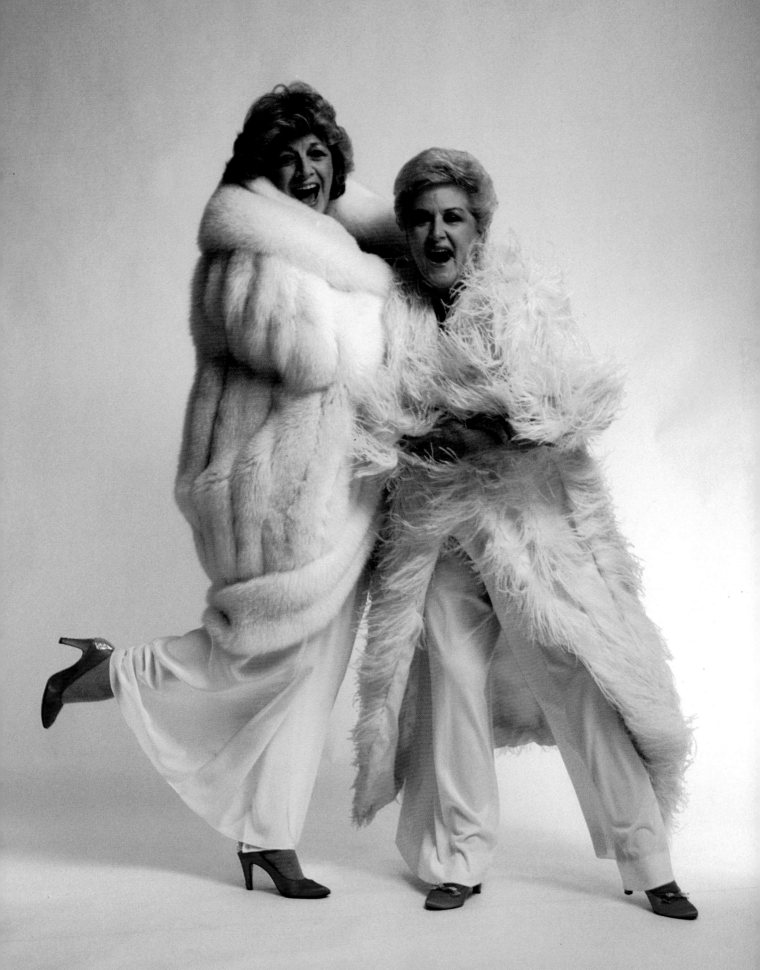

Cleanliness is
next to Godliness.

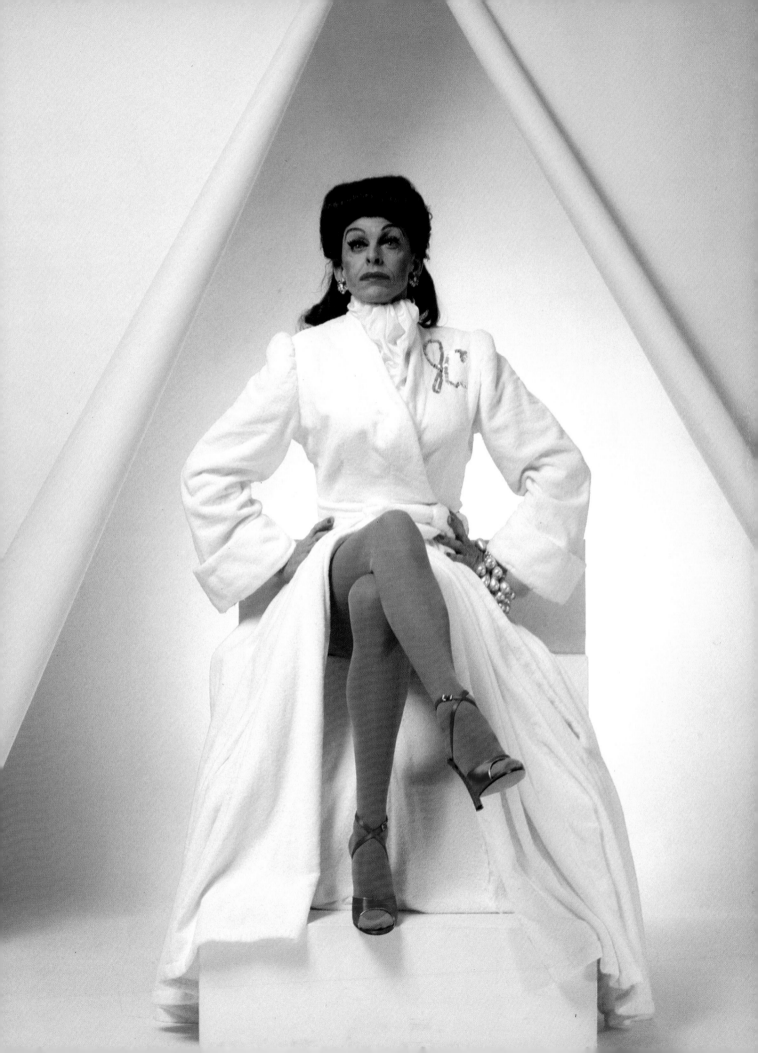

Playmates.

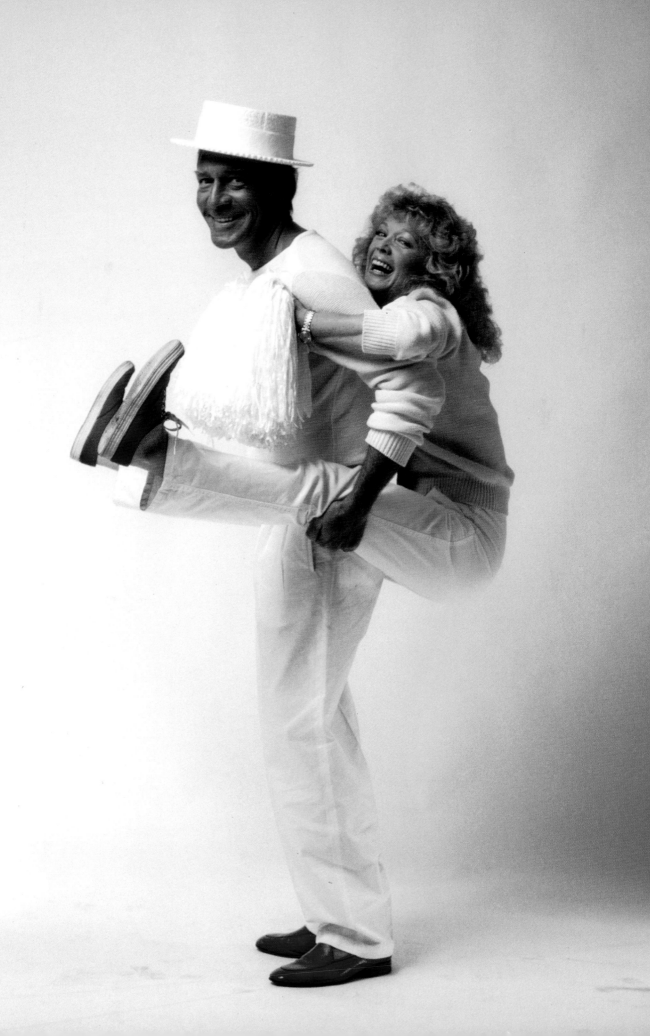

Always busy being funny,
we rarely get to see
this side of her.....
Can we talk?

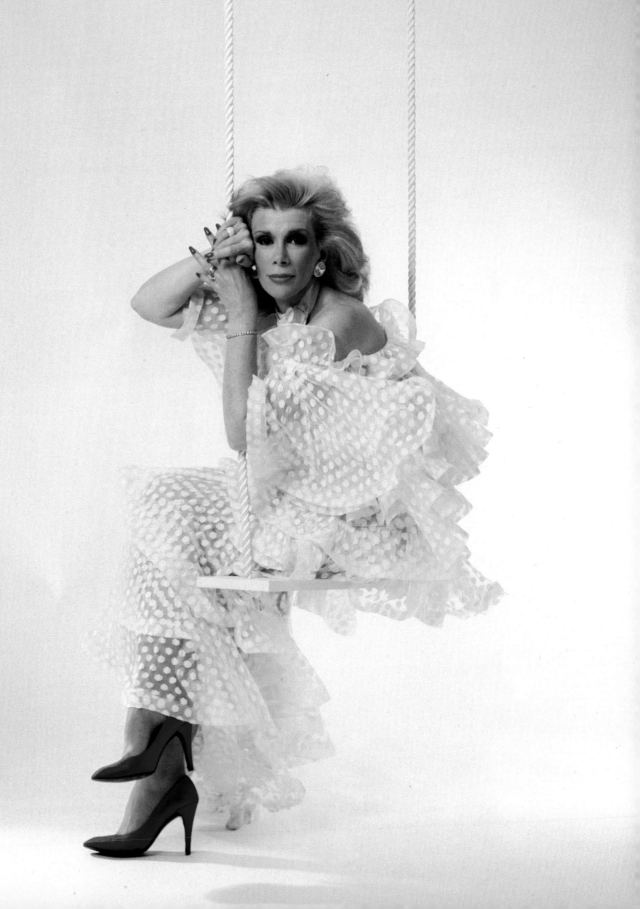

Internationally acclaimed dancer
and actress, she shows off
those mile-long legs.
She came, she saw,
she conquered,
and she LOVES IT!

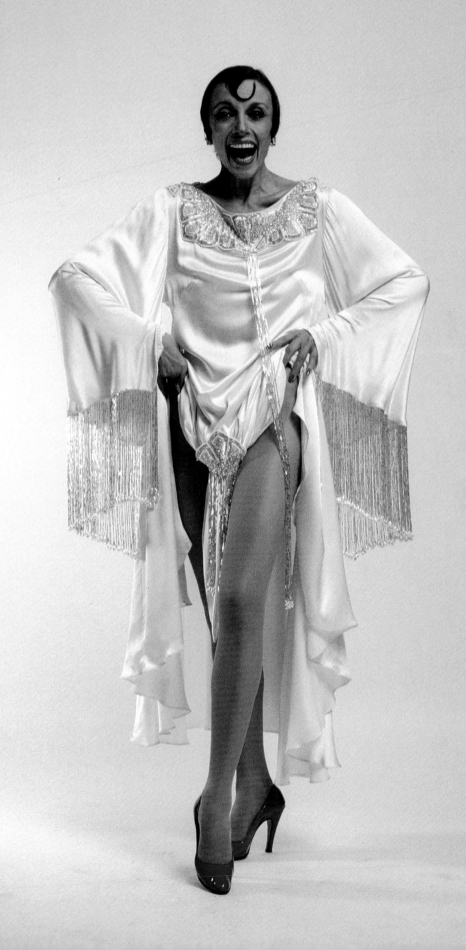

Truly sensitive,.
and a fine actor, he says
that he doesn't want to be
known as a sex symbol.
Well, it's all Greek to me.

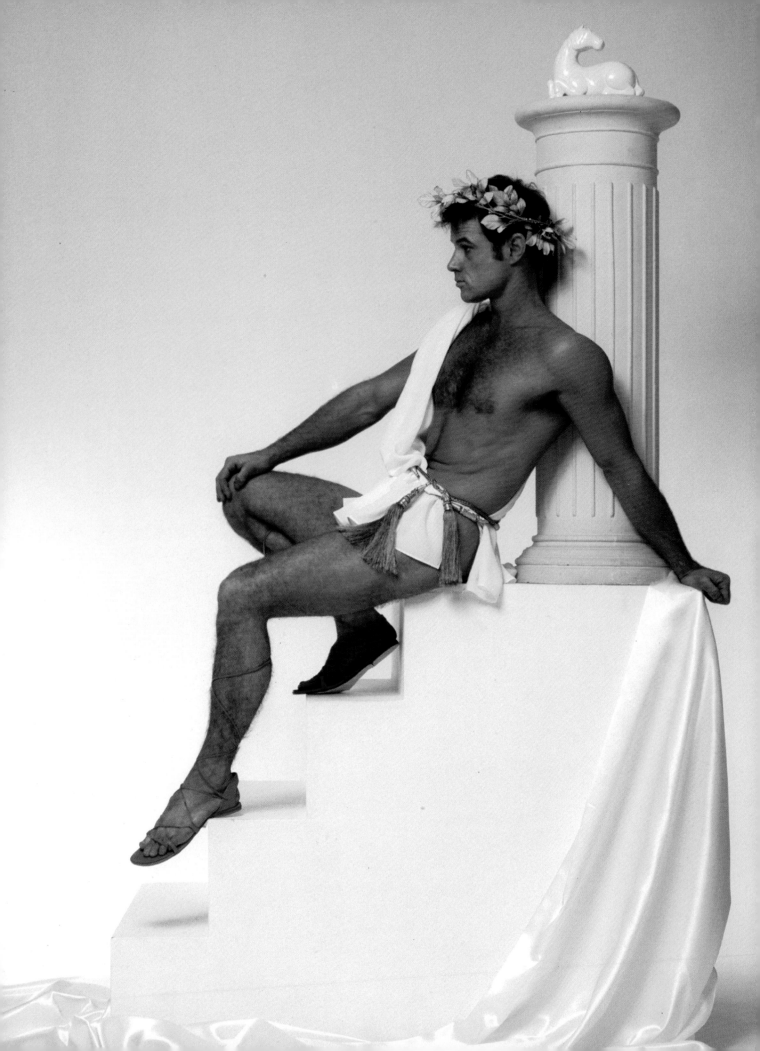

How can anyone forget
the loveable Bunny,
from the play *Gemini* ?

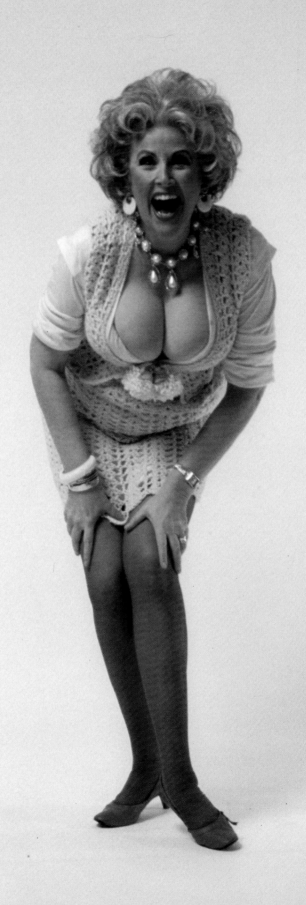

"I always wanted to be a
gas station attendant when
I was growing up.
I love the smell of gas.....
'Leaded or unleaded?' "

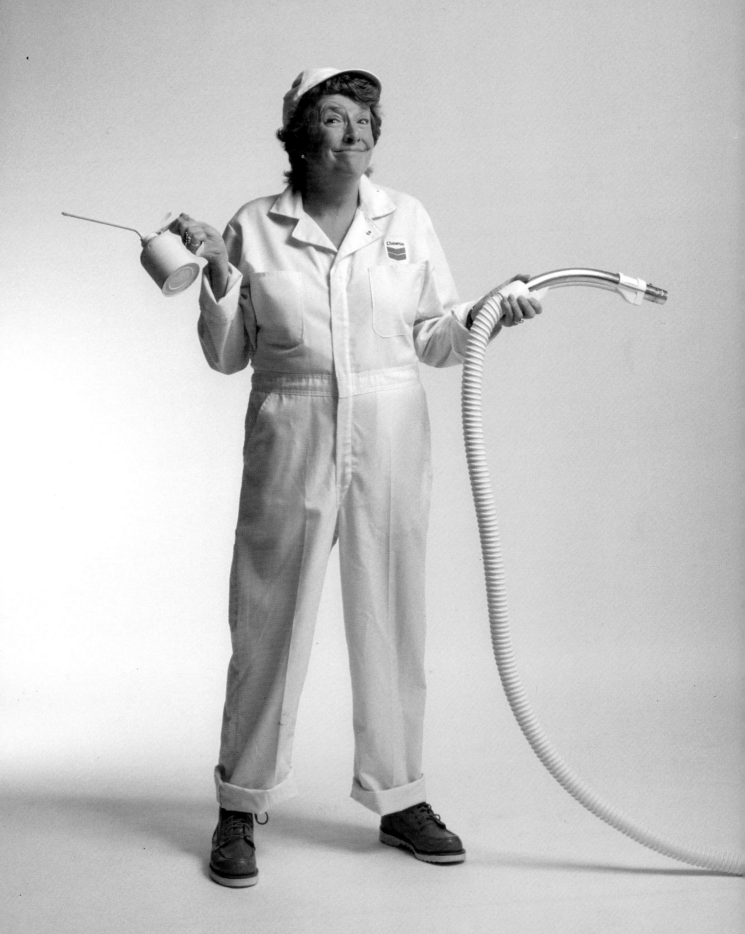

So you wanted
to meet the Wizard?

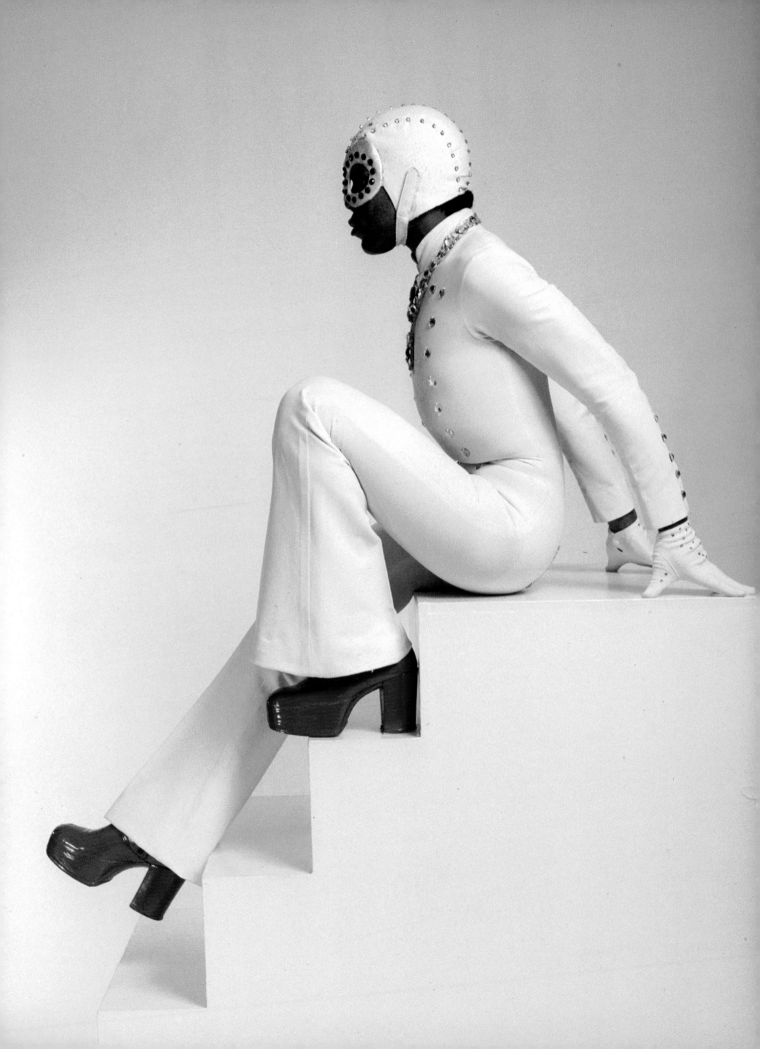

Such a love for
dance . . . this is one of
Paul's favorite pictures.

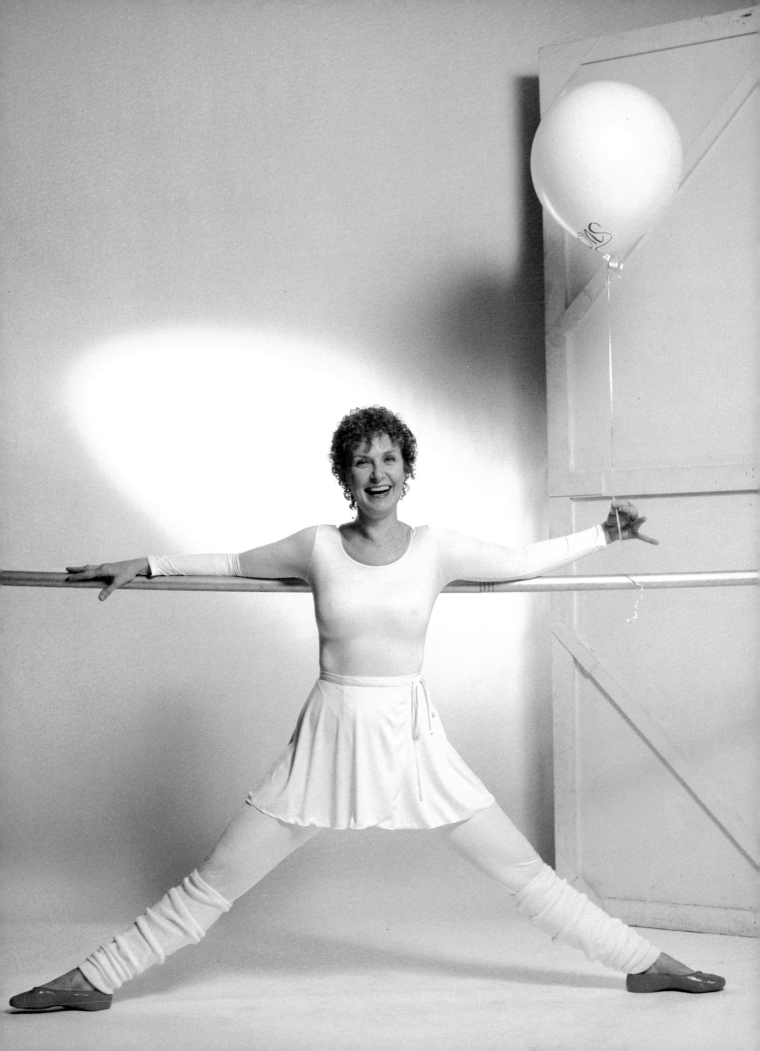

The epitome
of elegance on the ice.
On a scale of 1 to 10…he's 10!

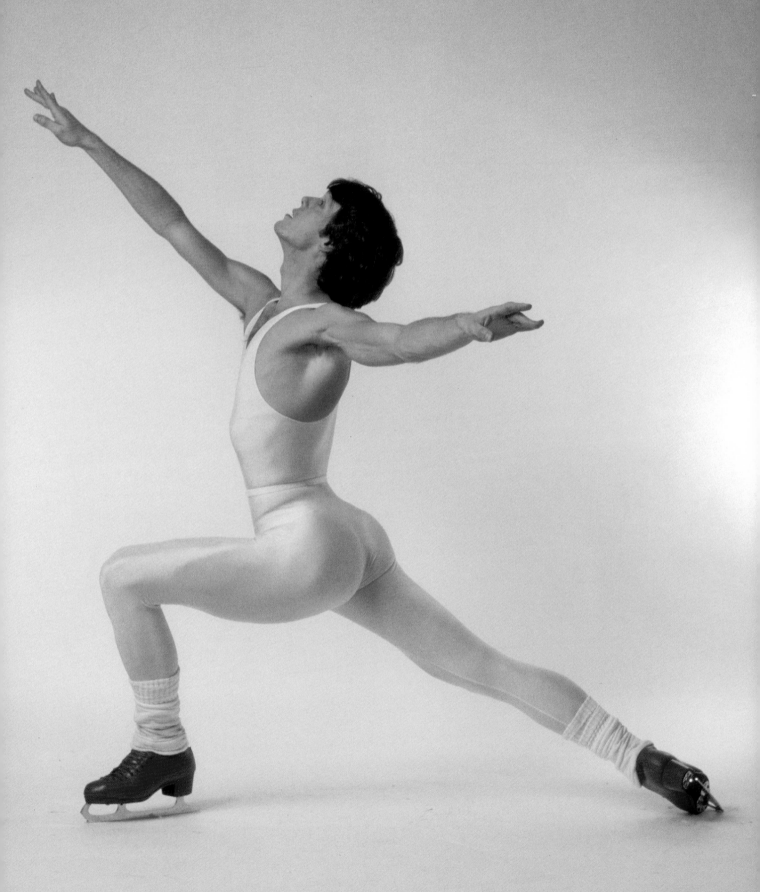

A classical costume,
a white cane, straw hat and
red shoes—and you're
"On Your Toes."

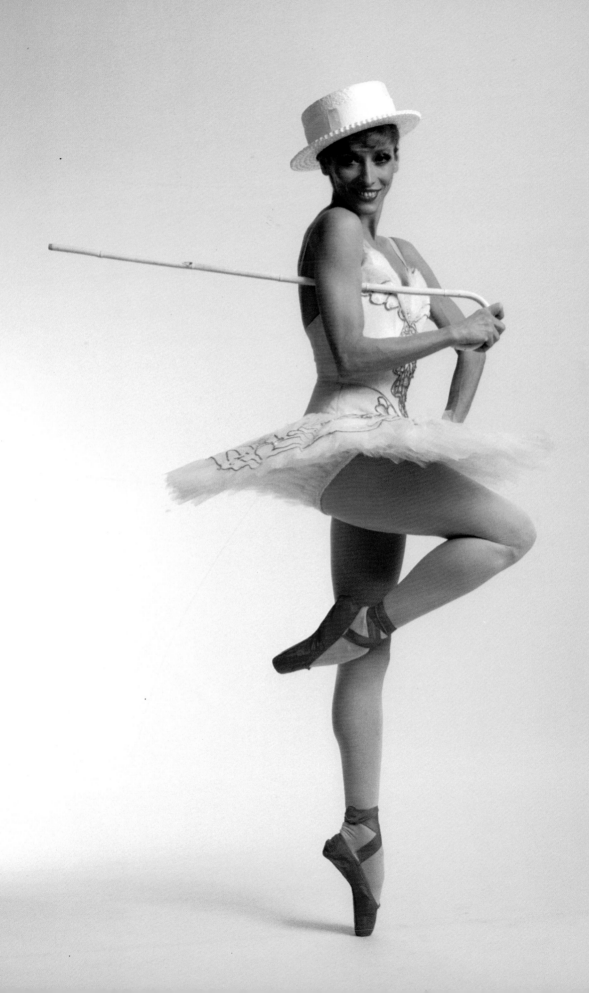

Dance is life.

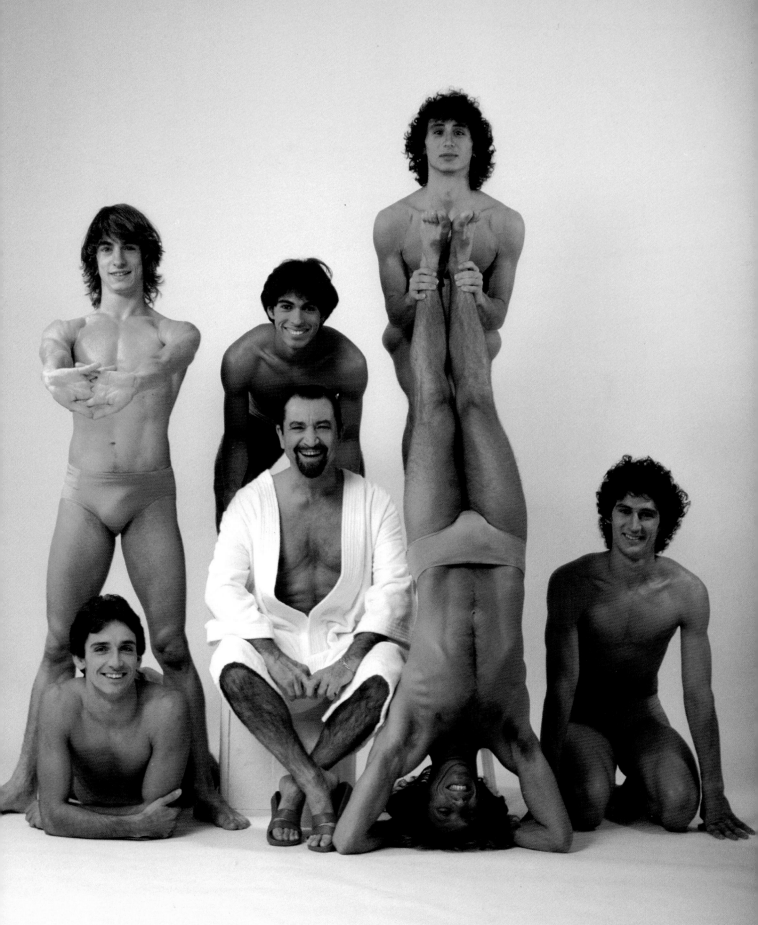

Look out, Bo Derek,
here comes Tarzan!

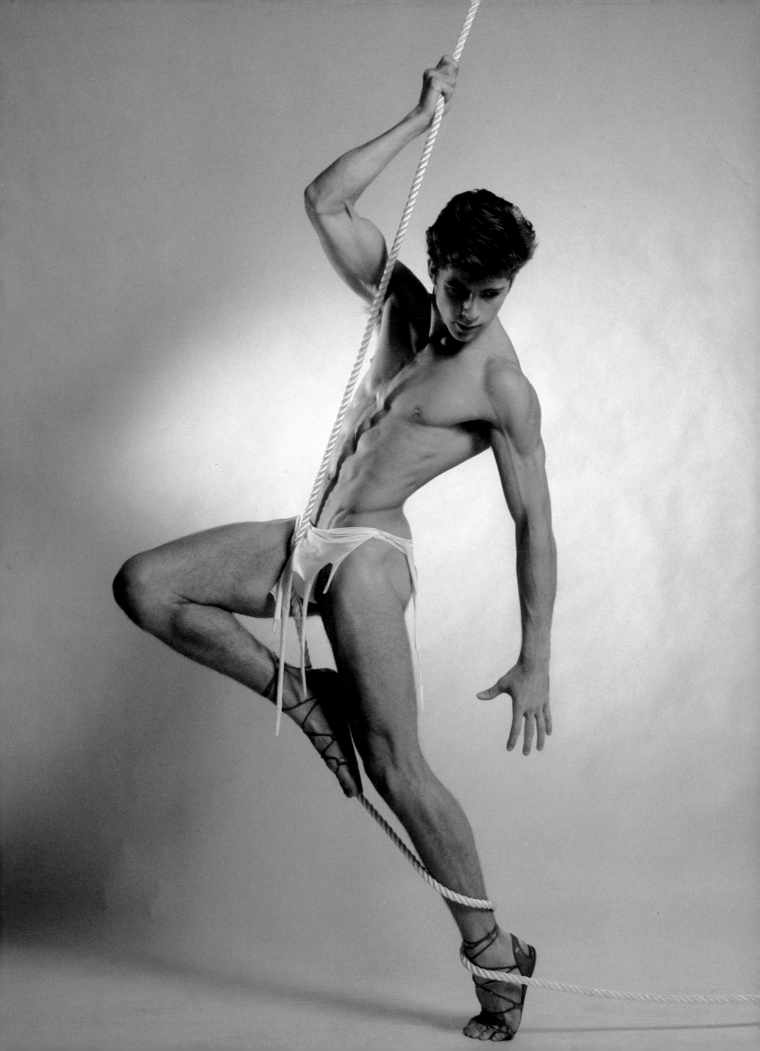

Remember the "Pinup Girl?"
Well, she has returned
once again and is divine.

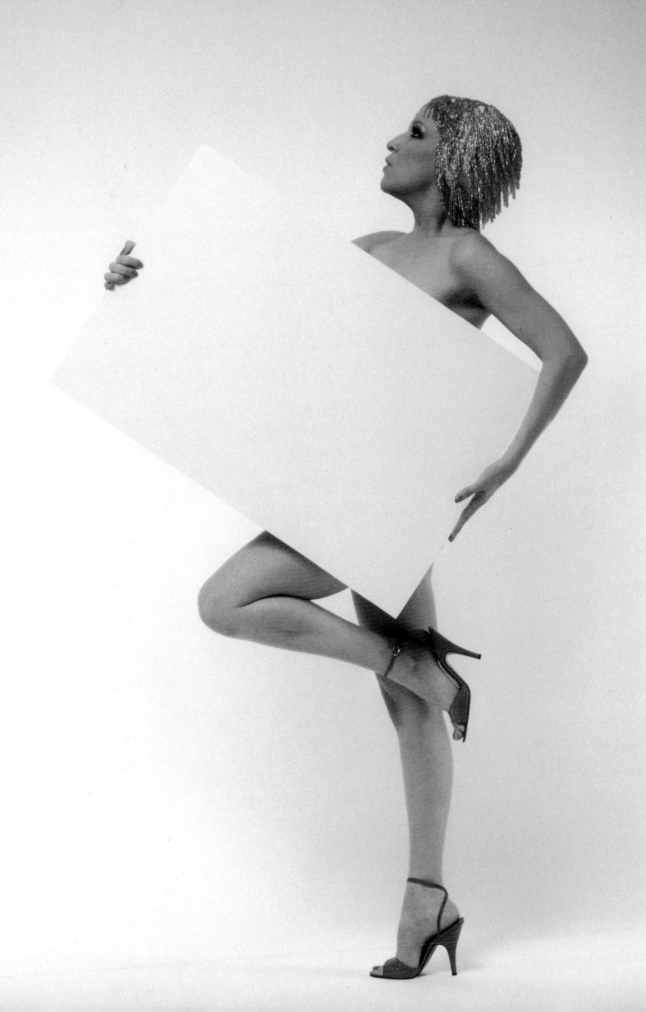

Never before has
such an extraordinary circus
performer (and his sidekick)
so completely captured the
fancy of the American audience.

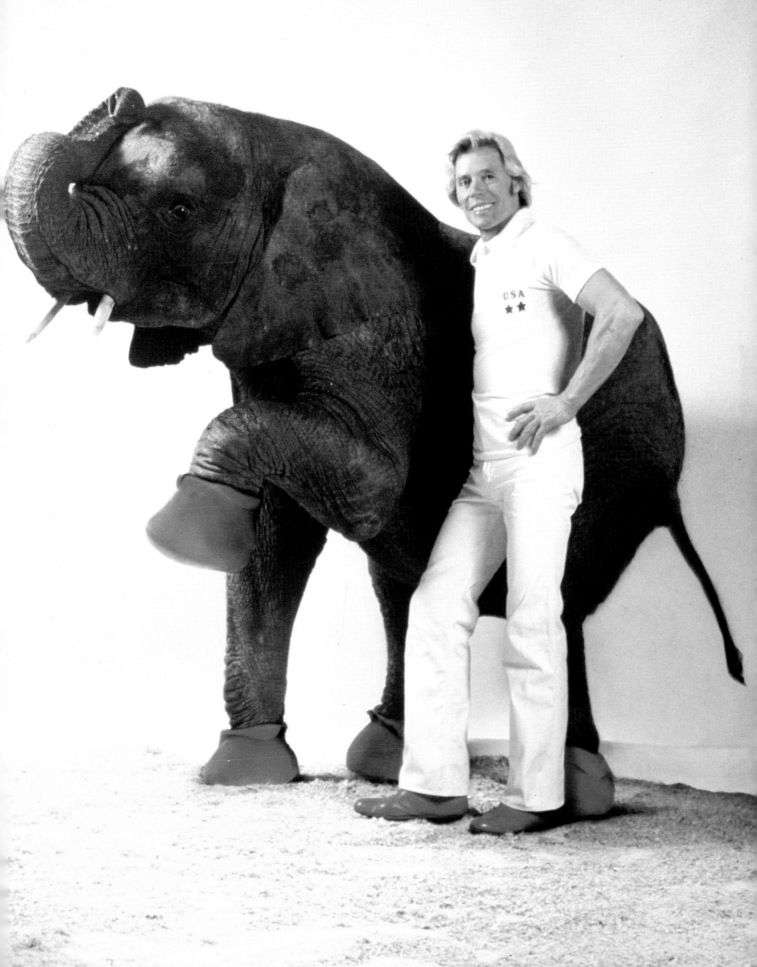

She is truly
"The Sophisticated Lady."

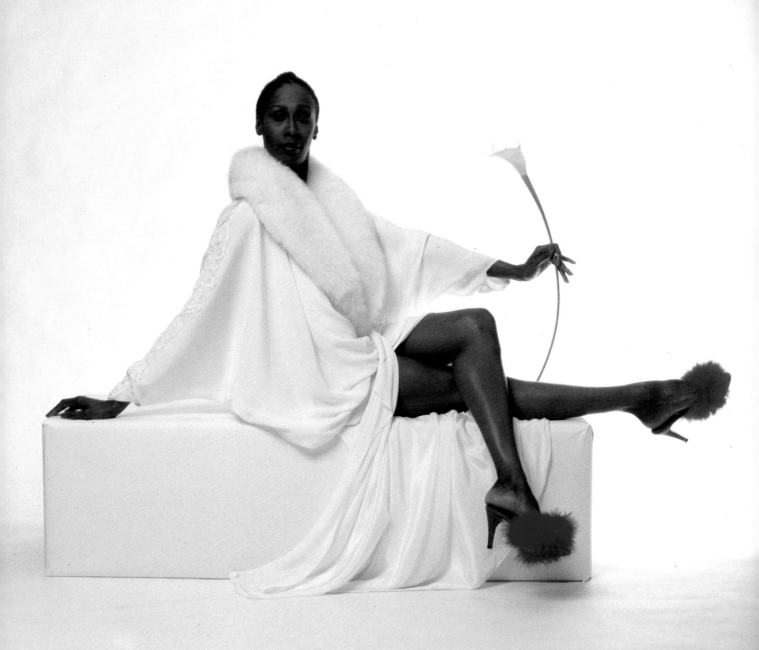

A mischievous look makes one
think she's out for Tom Jones
and not The Elephant Man.

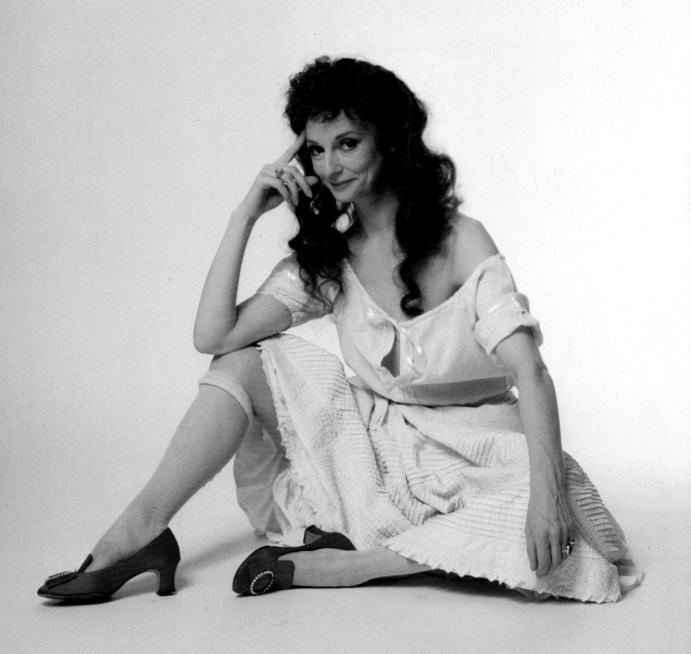

By the time he finished
painting his red shoes
the can was empty and nothing
was left on the bottom!

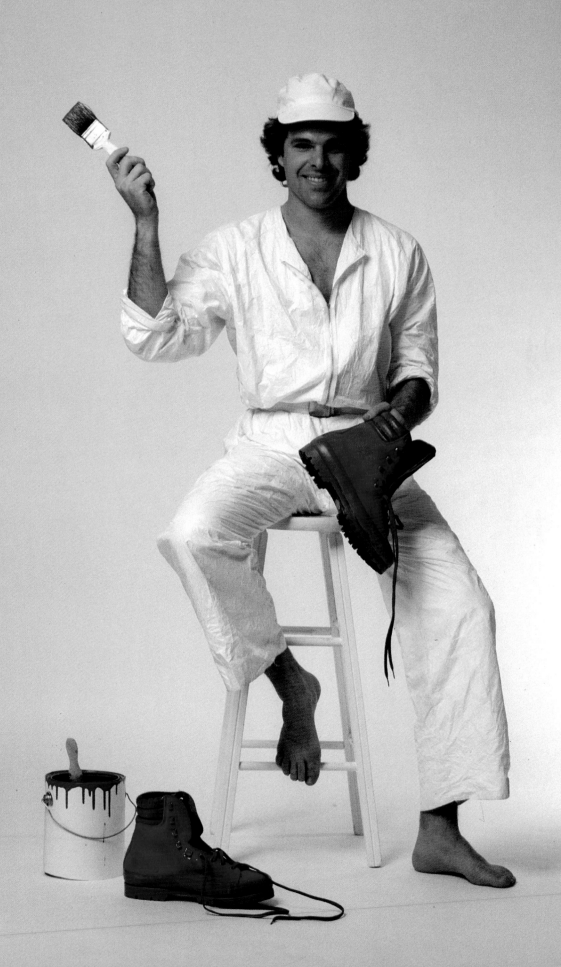

My One and Only stars
fantasize being cobblers putting
taps on all the RED SHOES...
nice work if you can get it.

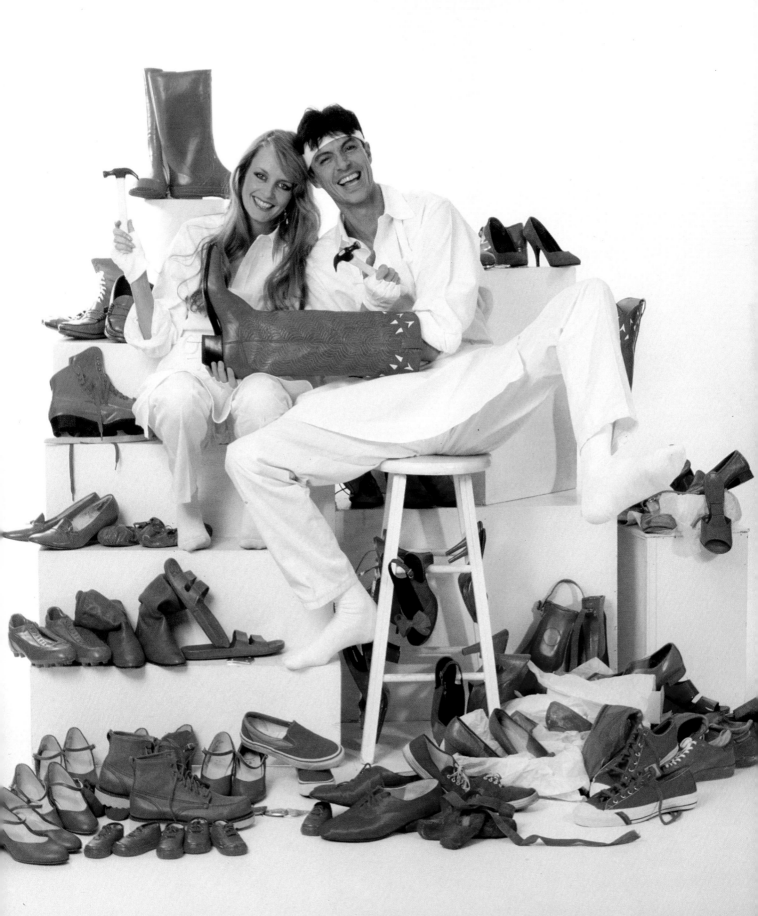

The Photographer

Marcel Marceau, after a photo session with Kenn Duncan,
turned to his manager and said, "He knows what he's doing, he's
an artist." Duncan's photographs capture the outer beauty and
inner essence, the wit, style, and soul of his subjects. Celebrities,
children, dancers, and ordinary folk—all are rendered
extraordinary by the Duncan lens.

The unifying theme in Duncan's varied work is the human form in
motion and in repose. Born in New Jersey, Kenn Duncan became
interested in movement early in his own development as a
roller-skating champion. Later, he studied ballet to perfect his form
and then abandoned skating for dance. An injury ended his
activities as a dancer; thereafter, he began his career in
photography—a career that has won him international acclaim.

One of the foremost dance photographers in the world,
Duncan has recorded the virtuosity of the principal ballet
companies and dancers of our time—both the Russians
(Baryshnikov, Makarova, and Nureyev) and the Americans (Cynthia
Gregory, Fernando Bujones, Judith Jamison, Gelsey Kirkland), and
the great Cuban, Alicia Alonso.

Duncan's photographs are in the permanent collections of
The Brooklyn Museum, the Chicago Historical Society, the Dance
Library of Israel, the Harvard Libraries, the Indianapolis Museum of
Art, the International Center of Photography, the New York Public
Library, the Parsons School of Design, the Smithsonian Institution,
and the Stedelijk Museum, Amsterdam.

"It is only when you have a sensitivity to what is beautiful and what
is not that you can begin to photograph. To be able to observe,
listen, and to communicate is the key to my work."

"I love people, I love life, and I love what I do."

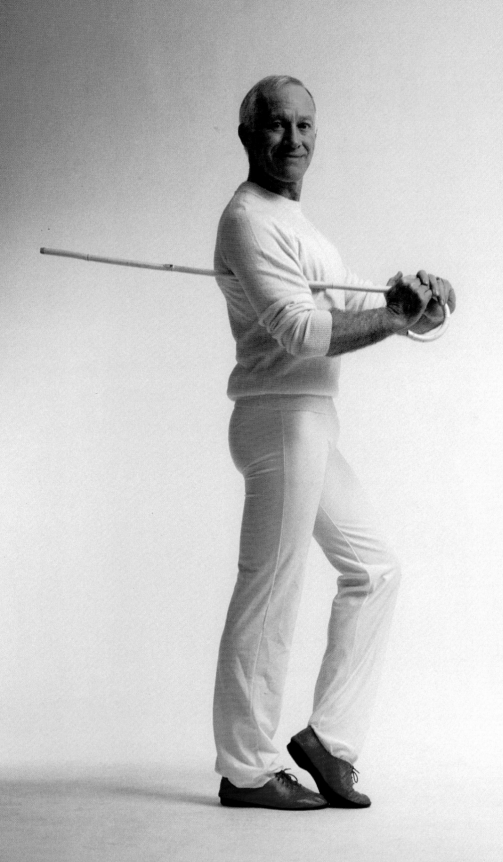

Acknowledgements

I am grateful to the wonderful and gifted artists who have shared and given so generously of their time to make this book possible.

A special thanks to Tony Chase for always coming to the rescue with his extraordinary fashion designs . . . a beautiful beaded gown, a fox fur coat, a loin cloth, a toga; nothing is too much for his exceptional talent. To Capezio; with the help of Richard O'Henesian for the coordination of shoes and dance wear. Ringling Bros. and Barnum & Bailey Circus and Arnold Bramow for setting up the logistics to photograph trainer and elephant in the Arena. Dawn Agency for Vanya, the white Russian wolfhound; Ostrovsky Piano Co. for the white Yamaha piano and Ron Kron for the marvelous Judy Garland doll . . . red shoes and all. Also, I would like to thank designers Geoffrey Holder, William Ivey Long, and John David Ridge for their costume designs from the Broadway shows *Timbuktu, Mass Appeal,* and *Amadeus,* respectively. To Christie's Fine Art Auctioneers for allowing me to photograph the original Judy Garland magical ''red shoes,'' and to Richard Alexander for his special help; Ira Wechsler for his support; the hair stylists, makeup artists, and all who have contributed to these wonderful photo sessions.

And last, very special thanks to Frankie Malifrando, whose enthusiasm, belief, and dedication have made this book possible.

THE PLAYERS